Postcard History Series

Manhattan's Chinatown

On the cover: In this real-photo postcard image taken in 1937, a large crowd of people is gathered along Mott Street. The crowd is engrossed by the orator's words. (Author's collection.)

POSTCARD HISTORY SERIES

Manhattan's Chinatown

Daniel Ostrow
Foreword by Mary Sham

Copyright © 2008 by Daniel Ostrow
ISBN 978-0-7385-5517-1

Published by Arcadia Publishing
Charleston SC, Chicago IL, Portsmouth NH, San Francisco CA

Printed in the United States of America

Library of Congress Catalog Card Number: 2007929952

For all general information contact Arcadia Publishing at:
Telephone 843-853-2070
Fax 843-853-0044
E-mail sales@arcadiapublishing.com
For customer service and orders:
Toll-Free 1-888-313-2665

Visit us on the Internet at www.arcadiapublishing.com

Dedicated to my Mom, Barbara. If it were not for her motivation, this book would never have been written.

Contents

Acknowledgments		6
Foreword		7
Introduction		9
1.	Early Chinatown Businesses	11
2.	Street Scenes of Chinatown	21
3.	Chinese Restaurants	43
4.	Chinese Tuxedo Restaurant	59
5.	Churches and Chinese Temples	65
6.	Pell Street	75
7.	Mott Street	91
8.	Doyers Street	105
9.	Original Chinese Theater	117
10.	Mulberry Bend Park	123

Acknowledgments

I wish to express my deepest and most sincere thanks to the following people: to Arcadia senior editor Erin Vosgien whose poise, patience, and kind nature I found to be a shining light; to Raney Yeung whose friendship and computer skills go unsurpassed; to my friend Dave Lee whose friendship I cherish; to my friend Rainbow Wong whose friendship I cherish; to my sister Debbie and my brother-in-law Mitch who for three months sacrificed his hobby/computer room for my use during the writing of this book; and finally to my niece Robin and my nephew Kevin for their love and support.

Unless otherwise noted, all images are from the author's collection.

Foreword

Having been born and raised in New York City's Chinatown and having been a teacher for the New York City public school system, I appreciate the educational value that a local history book such as this can provide to the reader. I feel a great sense of love, pride, and devotion for New York City's Chinatown. Having taught school in the Chinatown community for over 30 years, I sense a loss of identity among many of the young people of the Chinatown of today. It saddens me to see that many of them lack that same strong connection to our Chinese heritage that we had when we were youngsters. I feel it is of critical importance that all people maintain a strong tie to their cultural roots, as well as the traditions and teachings of their forefathers. Being familiar with one's heritage can offer much valuable enrichment and may enhance a person's character with qualities such as respect and honor. I find great value in the interesting scenes and historical images that are presented in this fine book and feel it may act as a catalyst to the reader inviting them to delve deeper into their own culture and history.

—Mary Sham

This northwestern view of lower Mott Street was taken in the early 1900s. It displays an unusually immaculate pre-festival Mott Street. Also a rare glimpse of the short-lived Imperial Restaurant at 5 Mott Street can be seen. The Imperial Restaurant was a very early competitor and next-door neighbor of the Port Arthur Restaurant. Notice how similar the two signs are in shape and style.

Citation

Ostrow, Daniel and David Ostrow. Manhattan's Chinatown. N.P.: Arcadia, 2008.

INTRODUCTION

In the mid-19th century, the United States became known to the Chinese as "Gold Mountain" and was attractive for several reasons. The prospect of gold, a high standard of living, as well as an option to send money back home to the immigrant's family, served as huge incentives in fueling Chinese migration to the United States.

Prior to the 1870s, it was comparably few Chinese who chose to settle in New York City. Most Chinese preferred the well-established Chinese communities of California. It was there that most of the financial opportunities in gold prospecting and in railroad work existed. In 1855, Quimbo Appo had become the first documented Chinese person to live in New York City. He made his living selling teas and tobacco. A few years later in 1858, a Hong Kong merchant named Ah Ken opened a cigar shop on Park Row. He became Mott Street's first Chinese resident. A few hundred of the very early Chinese to have settled in New York City relocated from Havana. To this day, Havana is famous for being the largest producer of the world's finest cigars. So it comes as no wonder that one of the primary occupations of the early New York Chinese settlers was as cigar makers. In about 1873, a Chinese named Wo Kee opened Mott Street's first Chinese retail business located at 8 Mott Street. At that time, Chinatown consisted of only three streets, Pell Street, Doyers Street, and the lower foot of Mott Street. With Wo Kee setting the trend, more Chinese soon followed. Businesses such as laundries, Chinese restaurants, curio shops, and Chinese general stores were flourishing in the enclave. However, up until the 1870s, the Chinese population in Chinatown remained relatively sparse. It was only when anti-Chinese sentiment, fueled by bigotry and racism, surmounted that Chinese migration from the West Coast to New York City began. By the 1880s, New York City's Chinatown was developing rapidly. New York City chapters of Chinese family associations, as well as Chinese fraternal organizations, were already in place. However in 1882, discriminatory legislation prevented Chinese from settling in the United States and becoming citizens. It also prevented wives and families of Chinese men from accompanying them, thus creating what would become known as "the bachelor society." It was only after the United States and China became allies in World War II that the Chinese Exclusion Act was repealed. Chinese women immigrated to New York City by the thousands and soon returned Chinatown to a community of families rather than single men. Finally in 1965, all discriminatory restrictions on immigration that were based on race were abolished. Today Chinatown is a thriving and vibrant New York City community.

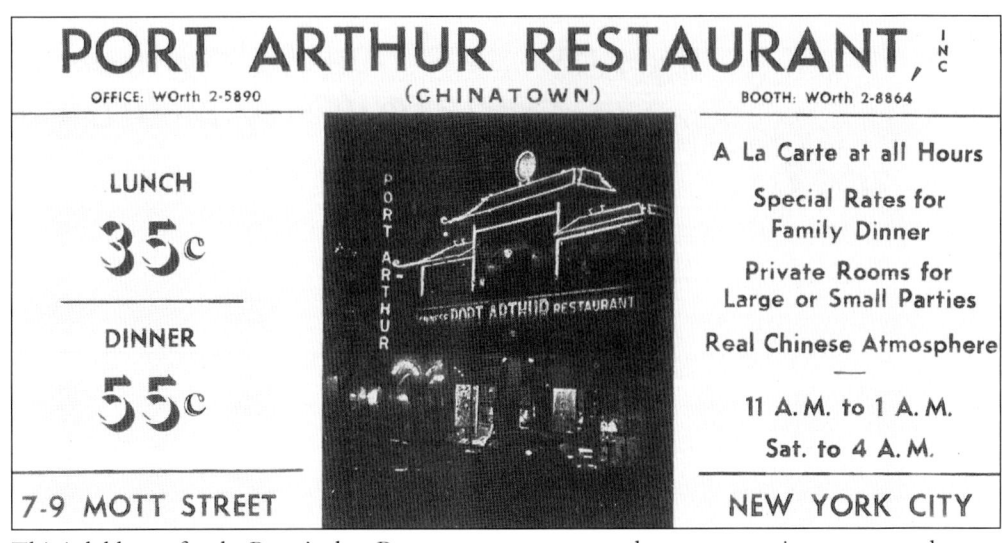

This ink blotter for the Port Arthur Restaurant was presented to customers just as postcards were to facilitate new business. One of the attractions was the low priced 35¢ complete lunch and the 55¢ deluxe dinner. This advertising was very effective, especially during the time of the Great Depression when they were issued. The Port Arthur Restaurant emphasized its "Real Chinese Atmosphere" and included a picture of the beautiful front of the building.

This ink blotter for the Lichee Wan restaurant, which was the Port Arthur Restaurant's competitor as well as next-door neighbor, advertised the exact same prices. The Lichee Wan emphasized its "courteous service and tastier Chinese food" and included pictures of food items. It also advertised that it was air conditioned. It was only in this aspect that the Lichee Wan restaurant surpassed the Port Arthur Restaurant. Air-conditioned restaurants were indeed a rarity in the 1930s.

One

Early Chinatown Businesses

The Port Arthur Restaurant was established in 1897 and continuously operated for over 85 years. Its original founder was Chu Gam Fai. The restaurant was named after a city in the northeastern China coast where the first victory of an Asian power over a European power occurred in 1894. The restaurant occupied the second and third floors of 7–9 Mott Street. The Port Arthur Restaurant was the very first restaurant to receive a liquor license in New York City's Chinatown. It had many different dining halls. The upper floor was reserved for private parties and banquets, while the lower floor was allocated for small groups or after hour slummers. *Slummers*, a term that started prior to the Gay Nineties, were American tourists in search of exotic adventure. Many local Chinese had their wedding parties and family ceremonial dinners at the Port Arthur Restaurant, as it was well known for its delicious Chinese dishes and delicacies. The Port Arthur Restaurant was equally famous for its authentic Chinese decor. These included inlaid pearl mahogany tables, teakwood chairs, ornate wood carved panels, and windscreens.

Soy Kee and Company was started by Chu Ho, who came to New York City in the 1880s. His store was originally located at 36 Pell Street. The second floor was occupied by the First Class Chinese Restaurant, which remained at that location until 1909. In 1897, he moved Soy Kee and Company to a former horse stable at 7–9 Mott Street and soon shared the building with the brand-new Port Arthur Restaurant. Soy Kee and Company was not only an importer of fine Chinese goods but an exporter as well. The store was well stocked with curios, chinaware, lamps, imported Chinese silks, embroideries, ivory carvings, imported Chinese teas, candies, dried fruits, coffees, canned foods, kimonos, pajamas, and many other items. In 1923, Soy Kee and Company opened on Fifth Avenue in the Dunhill Building where it remained for 10 more years.

This image displays the dinner menu for the famous Port Arthur Restaurant, which was located at 7–9 Mott Street. It had been a dining institution in Chinatown since 1899. This menu displays pricing representative of the 1930s.

Two successful businesses on Mott Street during the early days of New York City's Chinatown were Soy Kee and Company and the Port Arthur Restaurant. They were located above one another at 7–9 Mott Street, as depicted here in one of a series of postcards put out by Soy Kee and Company in 1899.

This postcard shows the gas-lit kitchen of the 1899 Port Arthur Restaurant. Typical of the time, one can see the ventilation intake area over the stove is non-screened. The ducts themselves were constructed of the same ornate pressed tin sheeting that was commonly used on tenement ceilings of the day.

The Port Arthur Restaurant was divided into several different rooms, each designed to fit the individual need of the clientele. This small area, described as a favorite nook, was ideal for use as a dining room during slow off peak periods and would most suitably oblige a sparse, wee hour's crowd. It would also be used to accommodate a small private party.

The Port Arthur Restaurant's main dining room contained the main entrance and the cashier's counter. It was the first room as well as the last room to be seen by the patrons. It was cooled by huge ceiling fans like the one pictured. In the cooler months, the blades would be repositioned to re-circulate the heat away from the ceiling.

Of all the Port Arthur Restaurant dining rooms, the East Hall was the most ornately decorated. Like the other rooms, it also displayed teak and mahogany inlaid marble, and inlaid mother of pearl tables, teakwood chairs, and intricately hand-carved teakwood room dividers, as well as decorative lanterns and chandeliers. For entertainment, the east hall had a baby grand piano.

This postcard shows the reception room for the Soy Kee and Company. It was not only a richly ornate waiting room bordered by Chinese windscreens and an elaborate altar table, but also a conference area where well-healed proprietors sipped tea with clientele as business was discussed.

FRONT VIEW OF BUILDING.
COMPLIMENTS
OF
SOY KEE & CO.
7 AND 9 MOTT STREET --- NEW YORK
WHOLESALE - RETAIL

In addition to the Port Arthur Restaurant and Soy Kee and Company, 7–9 Mott Street also housed the Chinese Empire Reform Association, as seen here in this front view displaying the entire building. This association was founded by Chinese Canadian activist Won Alexander Cumyow and was most active in the early part of the century. The Chinese Empire Reform Association was an organization comprised of overseas Chinese seeking a modernized China through progressive reform, rather than resorting to armed uprising.

Soy Kee and Company was divided into several different departments. Notice the wooden sign indicating the department located above the counter. The Soy Kee and Company tea and coffee department not only stocked many fine imported Chinese teas such as jasmine, oolong, and kee mum, but also coffees as well as accompanying teapots, coffee pots, and cups to serve them in.

This image shows the Soy Kee and Company silk and embroidery department. It stocked imported Chinese silks and embroideries in the form of handkerchiefs, tablecloths, shawls, kimonos, and pajamas. Behind the counter about midway, imported silk and embroidered Chinese clothing are displayed on hangers.

This front view demonstrates the beautifully ornate pagoda–style street entrance awning and the Chinese pagoda–style balcony that would become the trademark of the long-standing Port Arthur Restaurant. It also shows that Soy Kee and Company was not only an importer, but as the sign says, it was an exporter as well. The two separate entrances are easily distinguishable.

At the time of these images in 1910, the Soy Kee and Company silk department had been combined with curios. Curios are considered to be small decorative objects worth collecting. Some of the curios sold were ashtrays, paperweights, small ceramic cups and saucers, as well as carvings made of ivory and wood.

Unlike the previous view of the East Hall from a decade earlier, the East Hall of the Port Arthur Restaurant at the time of this 1910 postcard displayed a long banquet table already set up for use. It also showed a wall full of murals depicting Chinese nature scenes and people.

Adjacent to the East Hall is the West Hall. There was no wall or screen dividing these two halls. It was decorated with short, narrow four-person tables, which helped to distinguish them from one another. The purpose here was to have additional halls to serve smaller groups with the option to combine them to form one large banquet hall.

This very early menu for the Port Arthur Restaurant has a portrait of the restaurant's president Chu Gow on the cover. On the inside of the cover is printed, "In compliance with the public's long desire for a refined Chinese Restaurant, our management has taken the greatest of care, regardless of expense, to create the finest Chinese Café in America, . . . We sent our special envoy to Canton to order and superintend the manufacturing of our Teak wood and pearl inlaid furniture and pure gold carving works. Our cook is an originator and creator of many edible dishes." The lower image displays the first page of the menu. The prices show what it would cost to buy these dishes just prior to the beginning of the 20th century. The average beef dish listed was 25¢.

...BILL OF FARE...

1. YAKOMIN
 Noodle with Roast Pork and Chicken in Soup. .10
2. GAR MA MIN
 Extra Fine Noodle..... .15
3. GAI SOO MIN
 Noodle with Boneless Chicken and Ham in Soup25
4. AP TOY MIN
 Noodle with a Leg of Duck in Extra Fine Soup25
5. FONG WONG MIN
 Noodle in Pekin Style.. .35
6. WHAT GAI MIN
 Noodle with Spring Chicken in Extra Fine Soup50
7. CHOW YOK SOE MIN
 Fried Noodle with Threaded Meat and Bamboo Shoot, etc... .50
8. CHOW GAI MIN
 Fried Noodle with Boneless Chicken and Bamboo Shoot75
9. SOO CHOONG MIN
 Noodle in Shanghai Style Very Fine75
10. YONG CHOW WOR MIN
 Noodle Soup with Boneless Chicken, Ham, etc., in Yong Chow Style75
11. YEE FOO MIN
 Fried Noodle with Sliced Chicken, Ham, etc., Prepared with Fine Gravy 2.25
12. AN CHAI
 (Rice, per bowl)....... .05
13. CHOW LANG FAN
 Fried Rice with Ham and Vegetable25
14. CHOW SHUK GUM FON
 Fried Meats and Rice... .35
15. CHOW BAT BOW FON
 Fried Meats, Mushrooms, Eggs, Vegetables, Rice .75
16. CHOP SUEY.
 A Mixture Fried of Pork, Celery, Onion, Green Bean Sprouts. Very Popular15
17. GAR LEW CHOP SUEY
 Same as above, only better20
18. MO KWO CHOP SUEY
 Same as above, add Mushrooms25
19. GAI CHOP SUEY
 Very Fine Mushroom Chicken Chop Suey.. .35
20. NGOW YOK CHOP SUEY
 Chop Suey of Beef..... .25
21. LOT JU NGOW YOK
 Beef with Green Pepper. .25
22. Fan Kare NGOW YOK
 Beef with Tomatoes.... .25
23. CHOONG TAW NGOW YOK
 Beef with Onion........ .25
24. SOON CHOY NGOW YOK
 Beef with Chinese Pickled Green Kale.. .25
25. CHOONG TAW CHEE YOK
 Pork with Onion....... .25
26. FOO HUIE DAN
 Imported Ham and Egg. .50
27. CHARK SHU
 (Broiled Loin of Pork) 10 & 25

Two

Street Scenes of Chinatown

Not only does Chinatown have interesting street scenes, but they are also backdropped by New York City's most ancient tenement houses. The city's very first tenement building is located in the heart of Chinatown at 65 Mott Street. This seven-story walk-up was built in 1824 and was surrounded by two-story wooden structures. It remained as what was regarded to be an eyesore until eventually the surrounding antique wooden structures were all replaced, and a uniform-looking Mott Street was finally achieved. Up until the late 1920s, horse and buggies would still be commonly seen in a typical Chinatown street scene. It was only by the 1930s when automobiles were becoming more affordable that the buggies went by the wayside. Another integral part of the Chinatown street scene, especially of long ago, was the large number of Chinese balconies adorning the tenement facades. These balconies provided the Chinatown street scene with a strong Chinese flavor. The balconies sometimes contained pagoda-style roofs, some of which had three tiers. These balconies usually displayed a sign with either a family association or a restaurant name affixed to them. Many times the moldings, railings, and the panels of the balconies were painstakingly decorated with intricately ornate handmade woodcarvings. During Chinese New Year, the scenes were accentuated with lion and dragon dances, kung fu–uniformed troops performing their martial art exhibitions, as well as the beating of the Chinese drum with Chinese music cheerfully being played in the background. Last, but certainly not least, is one more integral part of any Chinatown street scene, and that is the incredible array of advertising signs. Flamboyant Chinese restaurant signs in bright neon light up the night. Business signs embossed with Chinese characters contribute as well to make Chinatown's street scenes among the most colorful in New York City history.

Many artists have tried to capture Chinatown in their sketches and paintings. This 1968 art postcard displays a watercolor painted by E. Charles. The subject is the northwest corner of the intersection of Mott and Pell Streets. Although the image is inverted, the beauty of the scene remains unaffected.

This image shows Canal Street as it looked in 1820. Up until 1803, spring-fed Collect Pond covered what is today's Chatham Square. By 1805, the pond had become polluted by local tannery's industrial waste, and around 1808, a 20-foot drainage ditch was employed to drain the pond's rancid waters east into the Hudson River. The ditch remained opened until 1820, when it was covered and paved over with cobblestone.

This view shows the Manhattan Bridge approach as it looked in the 1920s. The Manhattan Bridge is one of three East River bridges that bring people from Brooklyn into Chinatown. It was officially opened in December 1909. Notice the trolley cars as well as the presence of horse-drawn cars.

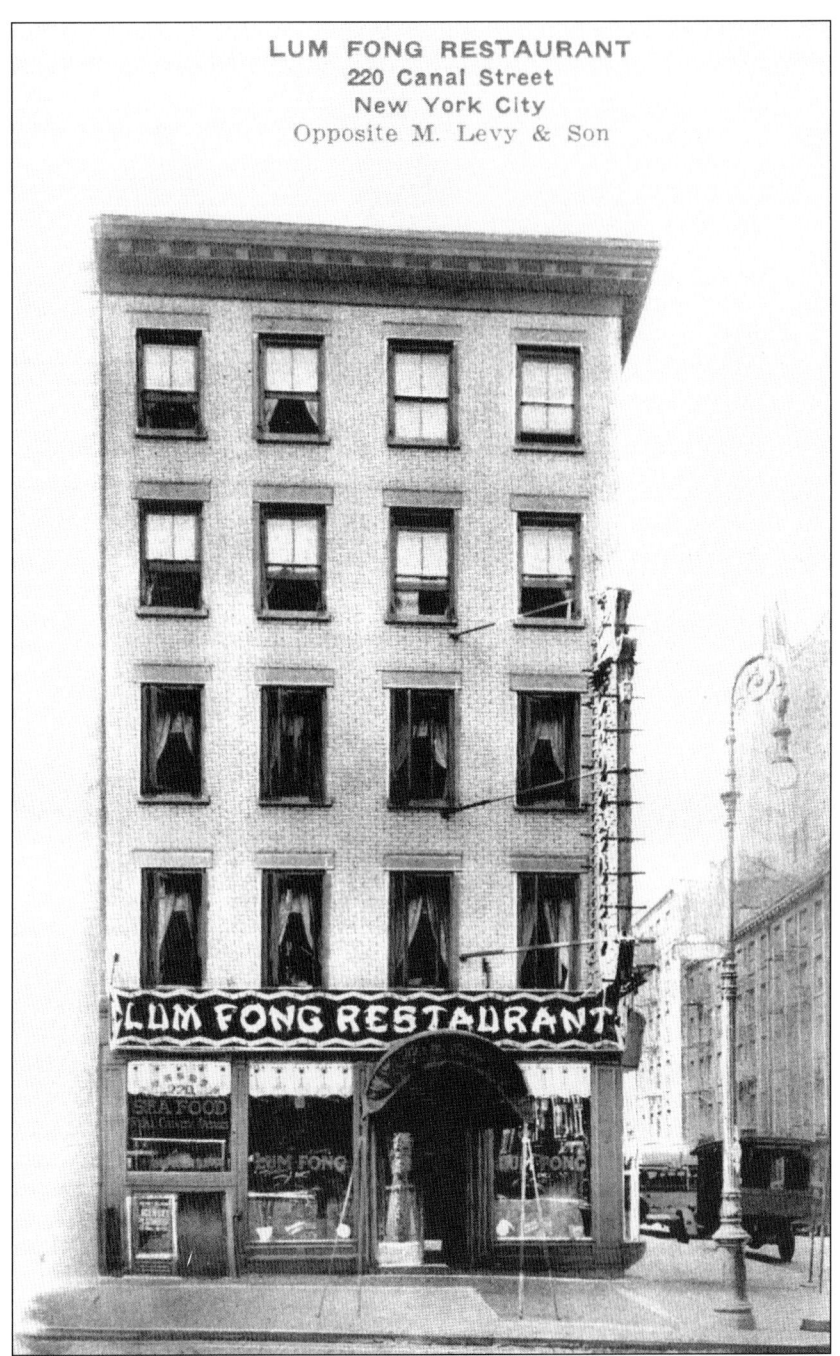

This advertising postcard shows long-standing Lum Fong Restaurant as it looked in 1910. The restaurant had a large incandescent sign reading "Chop Suey" mounted on the building. It was located at 221 Canal Street, at the corner of Canal Street and Baxter Street. Lum Fong was a well-known restaurateur who started out as a bookkeeper. Born in Canton, China, he was the son of Lum Tien Mook, a state legislator for Canton. Fong later opened an uptown branch of the restaurant, as well as Lum Fong's Casino in Long Beach, New York. Today Sun Say Gay Restaurant can be found occupying the same space.

This view shows the building directly across the street from the Lum Fong Restaurant, which contained Moe Levy and Son Clothiers, established in 1882. Moe Levy's son Isadore (Dorey) Levy met Lum Fong while he was managing a restaurant on Pell Street. It was then that the two became partners and opened what was to be the long-standing Lum Fong Restaurant.

This image from the early 1900s shows two men shopping in Chinatown. One of the men is still wearing his hair in the traditional queue while the other has a short western style haircut. Men wearing queues were still quite commonly seen in early-20th-century Chinatown.

This is a very-early-1900s street view of a young father holding his infant child. In Chinese culture, children are highly prized and adored. Captivated by the sweet innocence of the adorable baby, this doting dad and his friend are completely oblivious to the surrounding street environment.

This early-1900s image shows the entry counter to a fan-tan gambling den. In early Chinatown, the most common form of gambling was called fan-tan. During the early 1900s, Chinatown had roughly 80 locations where fan-tan was regularly conducted. The large, pool table–like structure located just in front of the counter was where the game was played. This image was inverted, as can be seen by the Chinese characters.

Bamboo baskets were commonly used to cart items in early Chinatown. This oilette postcard displays Mott Street as it looked in the 1890s. A man (right) can be seen carrying bamboo baskets up the steps at 16 Mott Street (the joss house), while another man in the street (back left) is also carrying a similar basket. Notice the small U.S. mailbox posted to the street lamppost.

This view shows a Chinese scholar who was both a teacher as well as an editor in early-1900s Chinatown. The first editor, as well as publisher, of a Chinese language newspaper in Chinatown was Wong Chin Foo, who in 1883 published the *Chinese American*.

This is another early view from this set of three Chinatown Raphael Tuck postcard images. This view displays an interior dining room that contains patrons preparing to order a meal at the Chinese Tuxedo Restaurant.

In the last view of this set, the interior of an early Chinatown gift shop is displayed. Here a proprietor is seen conducting business with Chinese as well as American patrons. In the upper right corner of the image, the large hanging bulbous figure is a paper lantern. The square object containing a circle that is hanging next to it is a lantern as well.

This oilette postcard view is of lower Mott Street in the late 1890s. It displays a street scene typical of the day. Some of the images seen include an ornate metal railing, a couple of wooden-wheeled carts, and several hanging wooden advertising signs.

In this next oilette postcard, two late-1890s policemen wearing tall bowler-type police hats stand across the street from an earlier location of Soy Kee and Company at 36 Pell Street. Both signs seen above the Soy Kee and Company sign are advertising the First Class Chinese Restaurant, which occupied the second floor. In 1909, Lee's Restaurant would occupy the address. (Please see page 49.)

This oilette postcard shows an 1890s Chinatown scene of an opium den being frequented by American women.

In this last oilette postcard, a typical 1890s Mott Street scene is shown. Two Chinese children can be seen walking hand in hand. The clothing worn by the children is typical of fashions worn by the Chinese in San Francisco.

This real-photo postcard shows the west side of Mott Street near Pell Street as it looked in 1937. Several business signs can be seen. The large restaurant sign mounted on the corner belonged to Lee's Restaurant at 36 Pell Street. The sign in front of Lee's Restaurant is Quong Yee Wo Company, a grocery store at 38 Mott Street. The Chinese balcony across the street is for Gee Kong Restaurant, which is located in this clear view of prefire 41 Mott Street. A "Chop Suey" sign is mounted on its balcony railing.

This real-photo postcard shows the west side of lower Mott Street. Most noticeable in this image is the unique Chinese pagoda awning at 13 Mott Street. At this time, 13 Mott Street was the home of the Chinatown Post Office and Kwong Ning Herbs as well as Moo Tai Joss House. Also seen is the sign for the Chinatown Emporium, an importer that replaced Eastern Importing Company at 7–9 Mott Street.

This real-photo postcard shows lower Mott Street as it looked from the air in the 1930s. Many famous restaurants and shops operated on this part of the street. This view also allows a glimpse of the lower Mott Street west side skyline.

In this real-photo postcard image taken in 1937, a large crowd of people is gathered along Mott Street. The crowd is engrossed by the orator's words.

This image is of Mott Street in the 1950s. It is a very busy view that is looking south from Bayard Street. The view contains the sign for the long-standing Joy Garden restaurant at 48 Mott Street, whose former large marquee and "Chop Suey" sign can be seen on the left of the top image. Across the street at number 45 is the sign for the Chinese Rathskeller Restaurant.

This view is of the east side of lower Mott Street. It was taken in the late 1970s. Some of the business signs are for the Peking Duck House, the China Lane Restaurant, the Mandarin Inn, the Szechuan Village Restaurant, and the Chinese Museum. The sleek new modernized 41 Mott Street building can be seen with its face-lift on the left.

This is an advertising postcard for the China Lane Restaurant located at 22 Mott Street when it first opened in the late 1930s. Famous for its blue rectangular storefront windows, it was popular not only as a restaurant but also as a banquet hall. In the image on the left the same fresh new sign as shown in this postcard can be seen as a 40-year-old relic.

This advertising postcard for the Peking Duck House was printed in 1988 when it was celebrating its 10th anniversary at 22 Mott Street. Famous for their Peking duck, the Peking Duck House is still in operation at their new location at 28 Mott Street. The Great Shanghai is a sister company that used to be located at 27 Division Street.

This view is of the large red pagoda-style building located at 183–185 Centre Street. This building sits at the corner of Canal and Centre Streets. Its ground floor contains a jewelry market, a Starbucks, and the East Bank.

Built in 1958, the Chinatown Community Center is located at 62 Mott Street. This image was photographed in the late 1950s or early 1960s. The Chinatown Community Center contains a large auditorium in its underground level that can sit 150 people. On the ground level, the Eastern States Buddhist Temple still has its storefront. Next door at 58 Mott Street was Wah Kue and Company, a long-standing stationery store.

This is a late-1960s view of lower Mott Street. The view is looking north and shows a very busy Mott Street crowded with vehicular traffic as well as pedestrians. It is a very festive time, as the street is adorned with decoration. The curved sign on the left used to show Lychee Wan. It now has a new name, Tung Luck inserted into it. (See page 48.)

39

This 1950s–1960s image is of Sang Wod and Company located at 50-A Mott Street, next door to Hoy Gee Coffee Shop and Joy Garden restaurant. Sang Wod and Company sold Chinese magazines, newspapers, and books, as well as postcards such as this one. It also sold herbal teas.

This image shows the Bowery as it looked in the 1970s. For many years, "Bowery bums" near Chinatown, like the ones pictured in this postcard, would commonly be seen to lie down where ever they felt tired and go to sleep.

In this late-1950s image of the northwest corner of Mott and Bayard Streets, people are seen out and about on a nice day in Chinatown. In this image, a Chinese-style phone booth with a three-tiered pagoda rooftop is seen at the corner. Also the Chinatown Community Center can be seen across the street on the right.

In the early 1970s, Chinatown, as well as the rest of the country, was enjoying a Kung Fu movie craze. At the center of it all was Kung Fu action movie superstar/legend Bruce Lee. One Chinatown martial arts supply store went as far as to install a gigantic advertising sign of Bruce Lee engaging in combat with Chuck Norris. This sign towered over Canal Street in Chinatown for many years.

This 1950s matchbook cover for Bo-Bo's, which was located at 20½ Pell Street, advertised as "the home of Chinese actors." Among the Chinese opera stars whose pictures hung on Bo-Bo's wall was Bruce Lee's father, who performed on tour in New York in 1959. At that time, Bruce Lee came to New York City to visit his dad. They ate in Bo-Bo's as well as the downstairs Wo Hop Restaurant.

Three

CHINESE RESTAURANTS

Since the days of the "slummers" in the 1870s, Chinatown has been best known for its Chinese restaurants. A major difference between the old-time Chinese restaurants and those of today is immediately noticeable in the restaurant signs. In the early days more often than not, the restaurant sign either said "chop suey" or "chow mein." The irony is that these dishes are not what one would find on the Chinese restaurant waiter's food plate at the end of a hard day. In fact, these dishes were more or less created or designed to suit western tastes. Chop suey was actually a combination of table scraps consisting of celery, bean sprouts, onions, and whatever else was handy, then stir-fried and put on top of rice. These early Chinese restaurants, as well as many Chinatown restaurants today, served customers day and night, up to and including the wee hours of the morning. The hard work involved in running a Chinese restaurant is attested to by the fact that even out of the most successful restaurants, it is but a handful that last longer than 30 years. Even the children of the very successful restaurants rarely opt to carry on, as it is not an easy task to run the restaurant. The parents encourage their children to use their education to pursue success in areas other than the restaurant industry. For Americans, a trip to Chinatown followed by a late night Chinese dinner was the icing on the cake of a great day of fun. The restaurant industry in Chinatown is big business. It has for many years provided solid employment for large numbers of Chinese immigrants. The head chefs as well as the second chefs command high salaries.

In this 1896 view of the interior of a Chinese restaurant, many Chinese patrons are seen enjoying their meal. The only non-Chinese aspect is the presence of showman Chuck Connors. For tips, Connors would bring thrill seekers and slummers to see the joss house. For extra money, he

would show them his "vice tour," which amounted to little more than a well-rehearsed scenario of friends portraying doomed opium addicts.

This very early view is of a Chinese restaurant frequented exclusively by Chinese patrons dressed in traditional Chinese garb. In the tradition of back home, the food is being eaten from bowls with chopsticks. Here the use of forks was not an option.

This image shows the interior of a typical early-1900s small chop suey house. This type of restaurant would stay open all night, catering largely to the slumming party crowd.

YAT BUN SING RESTAURANT
In New York's Chinatown

One of the popular Mott Street Chinese restaurants was Yat Bun Sing at 16 Mott Street. Pictured here in the 1930s, Yat Bun Sing had a wonderful theater marquee–type restaurant sign. Because of its increasing popularity, it had to enlarge its quarters to include the second floor, which had been the former site of the old Chinese school.

This advertising postcard, printed in the 1930s, was distributed to Yat Bun Sing's patrons. It illustrated, in ink drawing, many of the restaurant dishes featured in the menu. The restaurant was managed by Low Chong.

47

This image shows the Lychee Wan Restaurant located at 11 Mott Street as it appeared in the 1930s. It was advertised as a "restaurant of distinction." Although barely visible in the image, there is a beautiful large circular floor design. It was part of the original and expensively installed Terrazzo concrete floor. After Hong Ying Restaurant, a future occupant, closed its long-standing doors in 2002, the generation's old Terrazzo floor was covered with common floor tiles.

This earlier image shows the magnificent 1930s art deco storefront of the Lychee Wan. The inside was said to be decorated with Chinese wall decorations, which contained excerpts from the gifted pen of Li Po, a Chinese poet who lived during the Tang Dynasty (619–907 A.D.).

Lee's Restaurant was located at 36 Pell Street near the corner of Mott Street. Opening at this location way back in 1909, Lee's Restaurant's advertised as "the oldest Chinese restaurant in New York." Former occupants of 36 Pell Street included Soy Kee and Company and the First Class Chinese Restaurant (see page 30). Notice how a decorative windscreen was used to isolate the cashier's counter from the table.

Shown here are Lee's Restaurant's dining area and a decorative staircase. The restaurant owner's son was Calvin Lee, who at 36 years old became the youngest administrative head of a university in the nation. His illustrious career included assistant dean at Columbia, vice president of Prudential Insurance Company, and author of numerous books. After his father's sudden death in 1951, 17-year-old Calvin ran the restaurant until he was 24 years old.

This 1970s night scene postcard displays Chinatown's largest and most magnificent sign. It was for the Golden Dragon Restaurant. The sign featured a colossal three-story-tall neon yellow dragon wrapped around blue letters and red characters. The words *restaurant* and *air-conditioned* were in blue, as well as the dragon's mouth and cloud squiggles, while the word *bar* and the fireball were in red. The sign hung a short distance south of Canal Street on the west side of Mott Street. Erected in the early 1950s, this mammoth neon dragon represented New York City's Chinatown to generations of Chinese and Americans.

This is the early-1960s Golden Dragon Restaurant advertising postcard. It was located at 73 Mott Street. The Golden Dragon Restaurant boasted a Terrazzo concrete floor, which was left over from the days of the Paradise Chinese Restaurant, which previously occupied the space. Ironically the gigantic golden dragon sign promoted this relatively tiny restaurant/bar. The location is currently occupied by a footwear shop.

This 1950s advertising postcard is for the Pagoda Restaurant, which was located at 41 Mott Street in the original tenement building that existed before the fire. It had a prominent neon sign that accented their well-lit Chinese balcony. The Pagoda Restaurant employed the same ancient Chinese balcony that Gee Kong Restaurant enjoyed years before it.

THE RICE BOWL
CHINATOWN, NEW YORK.

The Rice Bowl Restaurant was located at 44 Mott Street. The Rice Bowl Restaurant had a large, red, vertical neon sign that featured a white rice bowl on top. The restaurant was founded by successful Chinese merchant and community leader Chin Suey Bing. It operated from 1939 to 1970. The Rice Bowl Restaurant was a sophisticated high-class restaurant that required gentleman to dress in suit and tie. It was also one of the first air-conditioned banquet halls in Chinatown.

纽约
华埠
大同酒家
中西美酒
随意小酌

THE RICE BOWL RESTAURANT
(IN THE HEART OF CHINATOWN)

This poster, as well as others sent from Shanghai, hung on the Rice Bowl Restaurant walls. In the 1930s, postcard portraits, such as these of Chinese women, were considered an iconic symbol of Shanghai advertising. The format mixed western style with Chinese tradition.

CHINATOWN'S OLDEST RESTAURANT
7-9 MOTT STREET, NEW YORK CITY

This is one of the Port Arthur Restaurant's dual-view advertising postcards. These postcards were presented free of charge to the clientele. The postcard displays the balcony as well as the dining room and was published in the 1930s.

This is a dual-view 1930s advertising postcard for the China Lane Restaurant, which was located at 20 Mott Street. In the 1930s, many Chinatown restaurants had two floors. As seen here, China Lane Restaurant's lower floor had the main dining room, while the upper floor contained the bar and a private banquet room for all occasions.

This early-1930s multi-view image is for Lou's Chinese-American Restaurant. Lou's Chinese-American Restaurant was located at 91 Bayard Street at the corner of Bayard and Mulberry Streets. It had a bar and was an air-conditioned facility.

This mid-1930s multi-view image is for Wu's Chinese-American Restaurant, which was formerly Lou's Chinese-American Restaurant. Basically this was the same restaurant as its predecessor (Lou's Chinese-American Restaurant). Although the English name had changed, the Chinese name stayed the same. Some differences besides the name change included the addition of cushioned booths, and an updated front awning that now advertised the word *restaurant*.

This image was taken around 1910. Mandarin Restaurant was located at 30–36 Bowery Street. It promoted itself as "the most distinctive restaurant in Lower Manhattan." Large dance hall Chinese restaurants, like the Mandarin Restaurant, provided inexpensive food, an all night band, and a dance floor. Most of these restaurants were located uptown. The Mandarin Restaurant has since been incorporated into Chinatown's largest indoor parking lot.

This is the advertising postcard for Tai Yat Low Restaurant, which was located at 22 Mott Street. This image was printed in the 1930s. The restaurant was an air-conditioned facility that had one of the larger neon signs along lower Mott Street.

Four

Chinese Tuxedo Restaurant

The Chinese Tuxedo Restaurant was a high-class Chinese-American Restaurant that opened its doors in 1897. The Chinese Tuxedo Restaurant was faced with some very stiff competition. Several other restaurants opened within the same two-year period, also catered to the same upper-class clientele, and directly competed with the Chinese Tuxedo Restaurant. They included, to name here but a few, the Chinese Delmonico, which was located just around the corner on Pell Street, as well as the Port Arthur Restaurant located on Mott Street. These were also similar in that their clientele consisted of Chinese as well as Americans. The Chinese Tuxedo Restaurant was located at 2 Doyers Street at the corner of Doyers and the Bowery over a store that sold trunks. This location was excellent for several reasons. One of which was the proximity to the Bowery El. The passenger-filled trolley cars would pass so close that passengers could pull themselves aboard the Chinese Tuxedo Restaurant's ornately designed balcony. The restaurant's eagle-crowned balcony provided the ultimate free advertising sign. The convenience of the close proximity of the Chatham Square Station also provided an important advantage. It made the Chinese Tuxedo Restaurant, to those visitors intending to head north toward the popular Bowery, one of the first Chinese restaurants to be seen by these Third Avenue El Trolley car riders after stepping out of the station. They would not even have the opportunity of a peek at the Mott Street restaurants, as those would have already been behind them in the opposite direction. In addition to its many ornate and richly decorated dining rooms, the Chinese Tuxedo Restaurant boasted a large competitive menu making it a giant among the early-20th-century high-class Chinese restaurants.

This outside view of the restaurant's main entrance shows the colossal Chinese-style awning, which was crowned with a large wooden carved Chinese dragon. Multi-colored stained-glass panels were embossed with the word *restaurant*. Atop the vestibule, there is a sign displaying the name of the restaurant in Chinese, as well as a vertical sign displaying the English name. All of these postcards were presented free of change to the Chinese Tuxedo clientele.

One of the top high-class Chinese restaurants in Chinatown was the Chinese Tuxedo Restaurant. The beautiful balcony with its intricately carved teakwood panels seemed to leap out from the rest of the building with intent to catch the passerby's eye.

In this view of the inside of the restaurant, American patrons sit down to a well-set table with an awaiting staff at hand. The patrons' dress is consistent with the fashions of the early 1900s. Notice the intricately designed, pressed-tin ceiling, as well as the mosaic-designed tile floor.

This set-back view of the Chinese Tuxedo Restaurant's dining room displays a group of potted plants surrounding a water fountain. This was not only for the purpose of decor but for feng shui as well. The fountain, which contained carved wooden birds, was supported by a hand-carved, wooden dragon stand. Behind the fountain were teakwood windscreens. Intricate, hand-carved, double-layered wood molding was used as a room divider.

This interior view of the ladies dining room shows a chandelier and a large design of a dragon on the ceiling. Curtains that hung down from a large carved teakwood molding worked as the room divider. The tabletops were made of inlaid marble.

In this private dining room, a displayed sign advertising Horton's ice cream, as well as the Chinese and English menus, served as sparse reminders that this restaurant was located in America and not China. The managers pictured here clearly enjoyed business from both Chinese as well as American clientele and consistently relied on receipts to total on average $500 per day.

In this postcard, a gentleman performs on the piano, while the manager sits and studies the menu. The Chinese Tuxedo Restaurant's menu was competitively priced. An omelet stuffed with chicken, lobster, and ham cost $2 on the Chinese Tuxedo Restaurant's menu. Around the corner on Pell Street, the Oriental Restaurant and the Mann Fong Lowe Restaurant both had it on their menu for the exact same $2 price.

This postcard view, taken from the Third Avenue El Trolley, shows the full exterior of the Chinese Tuxedo Restaurant from balcony to rooftop. The Bowery El, or Third Avenue El, which ran until it was destroyed in 1956, is also seen. It provided convenient, trolley car transportation practically right to the Chinese Tuxedo Restaurant's ornate balcony. As the Chinese dragon crowned the Chinese Tuxedo Restaurant's main entrance, the American bald eagle perched atop its balcony.

Five

CHURCHES AND CHINESE TEMPLES

Chinatown has been the home to a great number of Chinese temples as well as many different churches. In Chinatown today, there is an estimated 60 Chinese temples and churches. In addition, Chinatown has a large number of family associations as well as other private organizations, whose temples are reserved exclusively for the use of its members. Many of these private temples are not always open to the general public and may or may not be advertised in local directories or phone books. The Sunday school movement in Chinatown had been around since practically the beginning of New York City's Chinatown. Missionaries and teachers would teach in schools on a one-to-one basis, and little by little, the small groups of Chinese who attended these Sunday schools would grow more and more and so would the numbers of the Sunday schools. The Transfiguration Church started having a Chinese attendance in the early part of the 1900s. Today the Transfiguration Church has the largest Chinese Catholic congregation in the United States of America. The First Chinese Presbyterian Church was established in 1910. And the True Light Chinese Lutheran Church and Sunday school was established in 1936. But today, after all is said and done, Chinese temples are still the most popular places for Chinese to worship in Chinatown today.

TRUE LIGHT CHINESE LUTHERAN CHURCH

This real-photo postcard image displays the exterior of the True Light Lutheran Church as it looked when it was first erected by the Atlantic Division of the Lutheran Synod in 1949. It is a six-story-high building that is located at 195 Worth Street at the corner of Worth and Mulberry Streets. It fashioned a three-tier pagoda-style roof. The True Light Lutheran Church was first founded in 1935 as the True Light Mission by Mary E. Banta.

This is the main altar of the True Light Chinese Lutheran Church. Through the years, a great many Chinese couples took their vows before this altar. It was decorated in jade green and flanked by colorful red doors. Both sides of the altar bore an inscription that was embossed in Chinese characters. The inscription was taken from St. John's gospel 3:16.

This 1936 multi-view postcard is for the True Light Chinese Lutheran Sunday School and Church. The church was located at 173 Canal Street. The Sunday school was founded in 1935 and opened the following year. In 1936, the Reverend Louis T. Buchheimer was installed as the pastor of the church. On Easter of that year, the reverend performed the church's first baptism. In 1944, the church relocated to 199 Canal Street.

This is a very early real-photo postcard view of the Chinatown Mission. The Protestant interdenominational mission was founded in 1883 by the evangelist Tom Noonan, who was known as the "Bishop of Chinatown." In 1911, the Chinatown Mission (also known as the Rescue Society) bought the old Chinese Theatre building at 5–7 Doyers Street. (See pages 108 and 122.)

This postcard shows the Church of the Transfiguration. It was built in 1801 and is located at 29 Mott Street at the corner of Pell and Mosco Streets. The Georgian-styled structure was originally built as the English Lutheran First Church of Zion. With the arrival of the Irish in 1853, it became a Roman Catholic church. The church has the largest Chinese Catholic congregation in the United States.

THE GOD OF HAPPINESS

This huge Buddha was made from plaster and was the main attraction at this joss house that was located on the second floor at 5 Mott Street. This joss house was opened in 1926 by Poy Yee. He could not operate it alone, so he hired people to lecture on Chinese gods and customs and so impressed hoards of paying tourists.

This image is of the interior of the joss house that was located at 16 Mott Street. It was located there for many years and was one of the earliest of the joss houses. The intricately carved altar stand appears to have been used again in later years for the Wah Yan Mue Chinese Temple at 16 Pell Street. (Please see page 73.)

CHINESE TEMPLE IN HIP SING BUILDING

These two images display Fut Cho Mue Buddhist Temple. It was located at 16 Pell Street. This temple was the progenitor of the Wah Yan Mue Chinese Temple. The upper more distant view displays a Chinese-style circular archway entrance with front lower panels that are embossed with ying and yang symbols. The archway is topped with a pagoda-crowned panel that is embossed with Chinese characters. The lower image provides a close up of the altar where a Buddha sits. On both sides of the Buddha there are sculptures of a four-tier white pagoda. To the right of the table a huge gong can be seen. The Wah Yan Mue Chinese Temple looks to have used the same gong. (Please see page 73.)

CHINESE TEMPLE IN HIP SING BUILDING

71

In the mid-1950s, the Temple of Confucius was located at 2–4 Pell Street and was the only Temple of Confucius on the east coast of the United States. Confucius was born in 551 B.C. He was a Chinese philosopher and one of the most influential figures in Chinese history. His philosophy, which became known as Confucianism, is a complex system of moral, social, political, philosophical, and religious concepts.

The Ling Sing Temple, located at 24 Pell Street, was also known as the Temple of Buddha. In 1948, the temple, as well as the idols, was shipped to the United States from Peking. Most of the figures are more than 100 years old. The figures included a Buddha, a white ceramic statue of a pagoda, an inlaid pearl windscreen, lion masks, a six-sided lantern, and several ceramic idols. These postcards were normally distributed by the temples upon donation from the visitor.

These views display the Wah Yan Mue Chinese Temple in the early to mid-1960s. The temple was located above the Temple Garden Restaurant at 16 Pell Street. In the upper, earlier view, most prominent is the engraved altar that supports the Buddha. The front of the altar is faced with intricately carved tiles of ancient Chinese scenes. It is framed with intricately carved golden moldings. A large gong and some round paper lanterns are in the background. In the lower and later view, a number of changes can be seen. They include the addition of two Chinese gods to guard the altar, a decorative lion's head, and a pair of six-sided lanterns as well as two large decorative paper lanterns.

This postcard shows the 1962 altar for the Eastern States Buddhist Temple of America. Founded by Annie and James Ying in 1962, its storefront is still located at 64-A Mott Street on the ground level of the Chinatown Community Center. It is the first Chinese Buddhist temple established on the eastern coast of the United States for the exclusive purpose of introducing Buddhism to the modern western world.

Six

Pell Street

Pell Street is one of the famous early streets that composed Chinatown Proper. Pell Street is named after Joshua Pell Jr., who was a descendant of Lord Thomas Pell of Pelham Manor, England. An agent tried to sell a tract of land that is present-day Chinatown to Joshua Pell Sr. Although the deed was never recorded, the effort is memorialized in the present-day Pell Street. Through the years, Pell Street has contained many important businesses such as Lee Insurance at 31 Pell Street. The family has been operating at the same location since 1888. It was started as Tai Lung Company in 1888 by Lee Kee Lo. In the 1930s, Lee's Insurance became Chinatown's first full-service insurance agency. The company is still running strong today. Another successful business was the long-standing Chinese Delmonico Restaurant at 24 Pell Street, which was officially opened by Mayor William L. Strong in 1897. Pell Street was also the home of two early-20th-century high-class competing restaurants that bore the same American name on their signs and menus and stood directly across from each other. Neither restaurant would change their name. The Oriental Restaurant at 4–6 Pell Street was a direct competitor with the Oriental Restaurant located across the street at 3 Pell Street. They sold similar food and their menus reflected similar pricing. The Oriental Restaurant, at 4–6 Pell Street, to avoid customer confusion, added on the front of their menu, "This restaurant has no branches in Greater New York." Also on Pell Street was the Fung Wong Bakery, which opened in 1960 at 8 Pell Street. It has since moved to 41 Mott Street and has been continuously operated by the Choy family since 1960.

This early postcard was sold in gift shops in Chinatown. It shows a man walking east on Pell Street wearing a very long braid. The hairstyle, known as a queue, was still worn by many Chinatown Chinese in the very early part of the 20th century.

Chinese culture emphasizes strong devotion to children. In this second card of a set, a girl is seen escorting two children on Pell Street as a young man amusingly smiles at the scene. In this image taken during the early 1900s, the clothing worn by the young lady, as well as the children, is typical of fashions worn by the Chinese in San Francisco.

This postcard displays late-19th-century Pell Street. About half way down on the left side of the street, a non-mantled gas street lamp can be seen. In 1893, the technology for brighter white light mantle lighting was first developed. In 1904, there were 16,000 gas lamps in the Bronx and New York City that were converted to mantle lamps. These mantle lamps were three times as bright as the non-mantled.

Just beyond the postcard's left border, a telephone company pay station sign is seen. Local business owners conveniently walked here and paid their phone bill in cash. These heavy blue porcelain signs were commonly seen posted around the beginning of 20th century. Inside the bell it says "local and long distance." The signs were made in England and were distributed by "Sam Buckley & Company, 100 William Street, NY."

Both of these images feature Yee Hing Company at 20 Pell Street and were taken in the early 1900s. The view at right displays a quiet scene that was taken in the very early morning. A horse carriage driver wearing a skimmer hat is seen standing patiently next to a team of horses parked at the curb of the street. In contrast to the image at left, the lower real-photo postcard, which was taken in 1910 by George D. Rapp, shows a fairly busy street scene. A man is seen carrying well-wrapped paper packages while walking down the center of Pell Street. This scenario is highly unlikely to be found in today's heavily trafficked Chinatown streets.

This view of Pell Street is looking east toward the Bowery. It shows a sign for the Savoy Chinese Restaurant, as well as a large sign for the Chinese Delmonico Restaurant. The Chinese Delmonico Restaurant was one of the top high-class early-1900s restaurants in Chinatown. It was officially opened in 1897 by then mayor of New York City William L. Strong.

This image shows a group of American tourists gathered in front of the Chinese Delmonico Restaurant. Part of a typical tour of Chinatown would include dinner at a Chinatown restaurant, followed by a visit to the Chinese Theatre on Doyers Street. The clothing pictured is typical of the early 1900s.

This postcard was distributed by the Rescue Society with a donation envelope attached to it. It displays the dining room of the Chinese Delmonico, which boasted imported Chinese mahogany tables bordered by intricately carved moldings with mahogany unbacked chairs. The walls were decorated with three-foot-high carved wood moldings. On the back of the postcard is a printed message saying that the restaurant had a reputation of entertaining many Chinese statesmen.

This early-1900s image is also of the Chinese Delmonico Restaurant. This postcard was presented by the restaurant to its patrons. The room pictured is the "Ladies Dining Room." The beautiful, inlaid pearl tables with intricately carved side moldings are well displayed here. Cushioned unbacked chairs compliment a mosaic-designed tile floor. Mosaic-designed tile floors were commonly found in tenements of the day.

This image of the northeast corner of Pell and Mott Streets was taken in the early 1940s. The image features a small group of military men on leave visiting Chinatown. During the war years, many servicemen would return to New York City and plan dates with their girlfriends, friends, and family to visit Chinatown to celebrate their military leave. These postcards were quite popular.

This image shows an earlier 1930s view of the same intersection. Noticeable is the older 1930s-model automobiles. By the 1930s, automobiles were becoming much more commonplace in New York City's Chinatown. As seen in the image, finding a parking spot in 1930s Chinatown was a much more simplistic task than it is in the Chinatown of today.

This image of Pell Street looking west was taken in the 1930s. Most prominent in the view are the large restaurant signs. Many business street signs changed dramatically through the life of the business. The sign that used to advertise the Chinese Delmonico Restaurant had also changed since it first opened in 1897. In this image, it is seen as a huge vertical neon sign. (See page 80.)

This image of Pell Street looking east was taken in the early 1960s. Besides the newer-style automobiles and a whole new array of restaurant signs, the most noticeable difference in the view is the absence of the Third Avenue El Trolley, which had been running since May 1879. The Third Avenue El Trolley was destroyed in 1956, leaving Manhattan's East Side residents including Chinatown, with the already overcrowded Interborough Rapid Transit Company's (IRT) Lexington Line as the only railed transportation east of Fifth Avenue.

These images are of early- to mid-1960s Pell Street. They are both looking west toward Mott Street. As evidenced by all the new names on the restaurant signs, no matter how financially successful the restaurants were, only a handful of Chinatown restaurants lasted more than 30 years. Lack of children willing to take over the difficult job of running a restaurant and complications caused by partnerships are strong reasons why the successful restaurants close. Out of these two images, the only restaurant shown that is currently still in operation is Mee Sum Café at 22 Pell Street. These postcards were sold to tourists in Chinatown gift shops.

The following three postcards can be matched to their corresponding Pell Street storefronts, which all appear next door to each other in this early-1960s image. The three street signs shown and the three corresponding postcards include Crossroad Inn Chinese Restaurant (below), Wah Yan Mue Chinese Temple (upper right), and Temple Garden Chinese Restaurant (lower right). All three of these establishments handed out their own advertising postcards to patrons.

This image pictures the Crossroad Inn Chinese Restaurant at 18 Pell Street in the 1930s. The inn was actually only a restaurant. The word *inn* was added for the sake of style. Notice the cushioned booths and curved-backed cushion-seated chairs. These were quite different from the elegant mahogany tables and teakwood chairs of early-1900s Chinatown. (See image above.)

Wah Yan Mue - Chinese Temple, 16 Pell St. New York City

This image shows the interior of the Wah Yan Mue Chinese Temple at 16 Pell Street on the second floor. It featured an enshrined Buddha, a statue of Kwang Kung, and interestingly, the same ornate altar table that was featured in the early-20th-century joss house. (See page 73 and 86.)

The Temple Garden, 16 Pell St., Chinatown, N.Y.C.

This image is of the Temple Garden Restaurant around the late 1950s. The Temple Garden Restaurant was located at 16 Pell Street on the first floor. Except for the two Chinese characters in back, the six posters, and a soy sauce bottle on each table, this restaurant had a very American feel to it. (See the image on the top of page 86.)

This real-photo postcard shows a 1930s view of the northeast corner of Mott and Pell Streets. Notice the old indigo porcelain street sign. These signs were manufactured around 1914 and were still seen well into the mid-20th century. Unlike today's single street sign, one look at the sign indicated what street one was standing on as well as the name of the cross street in the intersection.

This real-photo postcard image is of Pell Street looking east towards the Bowery. This postcard was photographed in the 1930s. Notice the truck and the large amount of motor vehicle traffic present. With technology making the automobile increasingly more affordable, more and more Americans could own automobiles. As seen here, horse-drawn carriages in Chinatown had become a thing of the past by the mid-1930s.

This real-photo postcard image was taken in the 1930s. The view is of Liang You, a bookshop located at 27 Pell Street. Liang You not only sold Chinese books, but also Chinese postcards and newspaper magazines. Chinese book stores like these were more important to the Chinese immigrants of 1930s than to today's, as at that time, satellite television was unavailable.

This image was distributed by Kue Mee Realty Corporation located at 36 Pell Street. It appears to display the same northeast corner of Pell Street as the previous images show. If the image of the structures is not altered, this would be an extremely early view of this corner as it is pre-Chinatown. The misleading thing about the image is that either it had been enhanced to include cars and people styled after the 1920s, or it is actually an identical sister building located in a different part of the city.

Seven
MOTT STREET

If New York City's Chinatown was ever in need to choose a street to be dubbed Main Street, the honor would undoubtedly go to Mott Street. Mott Street crisscrosses every major intersection of Chinatown proper with the exception of today's Doyers Street, which originally was a private cart way off of Pell Street. In the 17th and early 18th centuries, the beef and cattle industries were prominent in lower Manhattan Island. Mott Street was named after one of the successful butchers of the day, Joseph Mott. Mott's ancestor was Adam de la Motte, who arrived in New York City from England in 1635. Little could Mott, who most likely had not even seen one Chinese in his lifetime, imagine that his name would one day be synonymous with New York City's Chinatown. Mott Street, besides being famous for Chinatown, is famous for another phenomenon. It contains the city's very first tenement building at 65 Mott Street. Built in 1824, the building at 65 Mott Street was a seven-story walk-up. The structures to both sides of it were two-story wooden structures. Typically the front room of the early tenement houses was 12 feet by 12 feet. It would be used for the kitchen, living room, and dining room. An 8-by-8-foot back room was used for sleeping. In 1873, Mott Street's first Chinese retail store, Wo Kee, opened at 8 Mott Street. Wo Kee was followed by more and more Mott Street Chinese businesses, many of which were Chinese laundries. Mott Street would continue to grow along with the rest of the enclave, until it would eventually surpass even San Francisco as the largest Chinatown in the United States.

KWONG SUN CHONG & CO.
30 MOTT STREET
TEL. 2839 WORTH NEW YORK, U. S. A.

Kwong Sun Chong Company was located at 30 Mott Street. This exterior view displays a very typical late-19th-century Chinatown storefront. The two display windows are divided by recessed, wood-paneled, double glass doors. The store's Chinese name is displayed above the doors as well as on the main sign. The entrance to the upper floor apartments of the same address is adjacent to the storefront.

KWONG SUN CHONG CO.
30 MOTT STREET,
TEL. 2839 WORTH NEW YORK, U. S. A.

In this interior view taken just prior to 1910, four well-dressed principals pose among the various merchandise displayed in their store. Some of the items they sold included porcelain dolls, flower vases, windscreens, lamps, chinaware, religious figurines, and custom clothing.

KWONG SUN CHONG CO.
30 MOTT STREET
TEL 2839 WORTH NEW YORK, U.S.A.

KWONG SUN CHONG CO.
30 MOTT STREET
TEL 2839 WORTH NEW YORK, U.S.A.

These are four of a set of Kwong Sun Chong Company advertising postcards. As the company promoted themselves to be custom tailors, these "fashion cards" were distributed to their clientele in hopes of generating customer orders for the same garments worn by the models pictured.

KWONG SUN CHONG CO.
30 MOTT STREET
TEL 2839 WORTH NEW YORK, U.S.A.

KWONG SUN CHONG CO.
30 MOTT STREET
TEL 2839 WORTH NEW YORK, U.S.A.

This early postcard shows the exterior of Wing On Wo and Company at 13 Mott Street, which is one of the longest, if not the longest, continually run retail businesses in all of Chinatown. It was the most popular store in Chinatown for Chinese and Japanese art goods. The company was founded in the 1890s by the Eng family. The business later moved to 26 Mott Street where it is currently still run by the Eng family. Later this same location would house Chinatown's first post office.

This photograph of Quong Yee Wo and Company was taken in 1903. The store was located at 38 Mott Street and was an importer of Chinese fancy goods and groceries. It was famous for its roast Chinese sausage. The cable address was listed as "QuongYeewo," the same as the company name.

Quong Yuen Shing and Company, located at 32 Mott Street, was a Chinese general store founded by Lok Lee in 1891. By the time it closed in 2004, it had been Chinatown's longest continuously operating store and had been run by three generations of the Lee family. In the early days, it sold general merchandise, which included Chinese groceries, porcelain, medicinal herbs, and Chinese restaurant supplies. During the old bachelor society days when many Chinese immigrants had no permanent home, the store functioned as an address to receive personal post. At one time, people lived in the back of the store. Although these two images were taken at considerably different time intervals, the store decor remained remarkably similar and did so up until the time of closing.

95

In this real-photo postcard of a parade in Chinatown, the anciently laid cobblestone street is clearly visible. All of Chinatown originally had cobblestone streets; however, in today's Chinatown, much of the cobblestone has been paved over.

This postcard of a Chinatown parade welcoming Dr. C. C. Wu was given out to patrons at the Chin Lee Restaurant in 1928. In May of that year, Wu was sent by the Chinese Nationalists to Washington as a special envoy of the New China. In November, he was appointed Chinese Minister to Washington. His father was Wu Ting-Fang who in 1896 also served as Chinese minister to Washington.

This view shows the west side of Mott Street just north of Canal Street during a 1970s Chinese New Year celebration. As seen in this image, the celebration involved heavy use of firecrackers. Firecrackers are no longer seen in New York's Chinese New Year celebrations as they were banned in 1997 by then New York City mayor Rudolph Giuliani.

The Dragon Parade marks the celebration of the Chinese New Year in Chinatown. This image shows dancers performing a lion dance. The lion dance originated in China close to 1,000 years ago. A dragon dance consisted of a team of 10 or more dancers, while the lion dance normally consisted of only two.

STREET IN CHINA TOWN & JOSS HOUSE, NEW YORK.

The three-story building in this image is 16 Mott Street. In 1883, an early wooden structure that existed there was replaced with the tenement building that still stands today. In 1890, it became the headquarters for the Consolidated Benevolent Association. The building contained a shrine for Kwan Kung, and for generations of tourists it would be known as the joss house.

In Chinatown, New York City.

In this early-20th-century northern view of the same section of Mott Street as above, the sign for Mon Far Low Restaurant at 14 Mott Street can be seen. Horse-drawn carriages were still, at that time, the most commonly used form of four-wheel transportation in Chinatown.

This view of early Chinatown effectively shows just how numerous the use of ornate Chinese balconies was at the dawn of the 20th century. Some were extremely well detailed with expensive hand-carved teakwood panels, while others were simply small terraces with a pagoda-styled awning.

This image shows Mott Street to be an unpaved dirt road. Actually the road's condition is caused by the remains of slushy snow and heavy horse-drawn vehicle use.

This oversized postcard was distributed by the American Loose Leaf Corporation in the 1970s. It shows a night view of lower Mott Street and features a Chinese-style public telephone booth. It was basically a standard telephone booth with the addition of a three tiers pagoda roof. It also had panels that displayed the words "public use telephone" in Chinese characters.

This postcard is an aerial view showing upper Mott Street looking south. The large pagodalike structure is 83–85 Mott Street, located at the corner of Mott and Canal Streets. This building houses the Chinese Merchants Association who at one time occupied 41 Mott Street. It is one of only two pagoda-roofed buildings left on Mott Street, the other being the last wooden one at 41 Mott Street.

This 1958 image shows the Chinatown Fair when it was located at 7–9 Mott Street. Although it contained an amusement arcade with mechanical rides, a gift shop, and a lunch counter featuring oriental pastries and ice-cream sodas, the Chinatown Fair is best remembered for Clarabelle, the scientifically trained performing chicken. She became a tic-tac-toe playing chicken when the fair relocated to 8 Mott Street. Admission was free. (T. C. Fang, 1958.)

This image of Mott Street in the early 1980s shows the massive Confucius Plaza in the background. Constructed in 1975 at a cost of $38,387,000, the 44-story tower block provided housing for thousands of Chinese Americans. In 1976, a large statue of the ancient Chinese philosopher was constructed and currently stands in front of the plaza.

The large white building is 41 Mott Street. Years ago, the original old tenement building was destroyed by fire. It has the only remaining wooden pagoda roof in Chinatown. At the time of this 1970s postcard, long-standing Hong Ying, at 11 Mott Street, had replaced Tong Luck, which had replaced long-standing Lichee Wan Restaurant. Also seen is the sign for the (downstairs) Wo Hop, a Chinatown dining institution located at 17 Mott Street. It has been in business continuously since 1938.

This older image of Chinatown shows that Mott Street in the 1930s had already been using street-wide banners for advertisements or to make public announcements. Especially in later years, and unlike the image, most of these street-wide banners contained Chinese characters. The characters were usually inked in the color red. In Chinese culture, the color red has long been believed to protect against evil.

This real-photo postcard of the intersection of Mott and Pell Streets displays a most prominent Lee's Chinese Restaurant sign. The long-standing Lee's Chinese Restaurant had been at the 36 Pell Street location since 1909. Its predecessor was the First Class Chinese Restaurant who at the same time occupied the building with Soy Kee and Company until Soy Kee and Company moved to 7–9 Mott Street in 1897. (See page 30.)

The Kee Chong Company was located at 51 Mott Street. In 1931, it advertised with its own store catalogue. This company carried many different products to meet their customer needs. Items included custom-made men's and women's clothing, pajamas, silk fabrics, bedding, mahjong sets, and Victrola records. The Kee Chong Company even had its own Chinese doctor who worked in the store every day from 6:00 p.m. to 11:00 p.m.

Tingyatsak Restaurant was a highly successful and long-standing establishment that was located down a flight of stairs at 21 Mott Street, at the corner of Mott and Mosco Streets. Tingyatsak Restaurant had a huge neon "Chop Suey" sign displaying a lantern as well as a heart with an arrow. Tingyatsak Restaurant closed in the late 1960s and was replaced by the equally successful, still-operating old-style Hop Kee Restaurant.

Eight
Doyers Street

Doyers Street is famous for being known as the most crooked street in New York City. It runs between Pell Street and the Bowery. In the late 18th century on the northeast corner of Doyers Street and the Bowery stood an alehouse called the Plow and Harrow Tavern. At that time, Doyers Street was no more than just a private cart way for the use of a large distillery located where the Chinatown post office stands today. Doyers Street received its name from the man who owned and operated that distillery, Hendrik Doyers. From 1893 to 1911, 5–7 Doyers Street was the home of the first Chinese theater in Chinatown. Doyers Street also housed the Rescue Society, which for many years aided the Bowery's homeless. Many successful businesses have operated out of Doyers Street. Some of these include Nom Wah Tea Parlor at 13 Doyers Street, which first opened in 1927 and is still operating today. Famous for their giant almond cookies, Nom Wah Tea Parlor still maintains its original interior, including the mosaic-designed tile floor and the ornate pressed tin ceiling. It has been used in the making of several movies. Another long-standing business includes Ting's Gift Shop, which is located at 18 Doyers Street on the northeast corner of Doyers and Pell Streets. Ting's Gift Shop has been at the same location for 50 years. In 1957, it started as Ting's Company, a fashion house selling Chinese dresses and accessories. The Tings later diversified to include fabulous Chinese toys, curios, and many other souvenirs. They are still in operation today. Doyers Street is also known as "Haircut Street," as it contains many of Chinatown's barbershops and hair salons.

CAFÉ MANDARIN.
Chinese Restaurant & Cafe Shanghai Gardens
11–13 DOYERS STR. Chinatown, NEW YORK, City,
Chatham Square Station. Near to Chinese Theatre.

The only Cafe in Chinatown.
Oriental Kitchen. American Drinks. Music. — Reliable Guides furnished to see the interesting sights of Chinatown.

The Café Mandarin was located at 11–13 Doyers Street. This postcard advertises that it was near to the Chinese Theatre and conveniently close to the Bowery El. It also advertises that the restaurant would furnish reliable guides to show customers the interesting sites of Chinatown. This was in direct competition with the numerous American motorcar companies of the day that would charge considerably more for their own guided group tours.

Telephone 2244 Worth

WO ON & CO.,
IMPORT and EXPORT MERCHANTS
CHINAWARE
CHINESE and JAPANESE
SILK GOODS
Embroidered Silk Shawls, Silk Handkerchiefs
FANS, FINE TEAS, Etc.

9 DOYER ST.,
Formerly 19 Pell St.,
NEW YORK CITY.

This advertising card for Wo On and Company was printed in the early to mid-1890s and was issued several years before the modern-day postcard came into existence. Wo On and Company was an importer and exporter of all sorts of chinaware, Chinese and Japanese silk goods, embroidered silk shawls, silk handkerchiefs, fans, fine teas, and such.

This private mailing postcard from 1898 was one of the very earliest of the Chinatown postcards. It was issued during the first year of the private mailing postcard. This very early image of Doyers Street is looking southeast from Pell Street. It features a busy scene with an abundance of people. A man in the center of the image is seen lugging five large wicker baskets, while a group of men examine the community bulletin board. Across the street, a policeman is talking to a citizen while a little boy stops to observe a leashed goat.

A group of well-clad American children are seen here enjoying their time in Chinatown. At the time of this image, Chinatown was frequented by many tourists and practically all the signs seen here are in English. The signs include H. Zang Milk Depot, Wing Lee Laundry, Wah Sing Restaurant, a huge building mural for Fletcher's Castoria, and the main entrance sign for the Chinese Tuxedo Restaurant.

The huge heart sign advertised May Sum Restaurant located at 3 Doyers Street. May Sum Restaurant would soon be replaced by the China Clipper Restaurant, which was named after a transoceanic flying boat used by Pan American Airways. On November 22, 1935, taking off from Alameda, California, it successfully delivered the first airmail cargo across the Pacific Ocean. The China Clipper location later became the Eurasia Restaurant. (See page 114.) (Leong and Chu, 1936.)

This view of Doyers Street is looking the opposite direction than the above image. Clearly seen here is the front of the Rescue Society at 5–7 Doyers Street. It took the place of the old Chinese Theatre. (See page 122.) Appropriately the Rescue Society used the heart as a reference point to guide many homeless so that they would know that they had arrived at the mission. (Ed Jackson, New York Daily News.)

This real-photo postcard shows the way Doyers Street looked in 1937. Just beyond the public bulletin board hangs a sign for 9 Mott Street that advertises Helen Moye Lee's famous gifts. Under the sign, a typical late-19th-century Chinatown storefront with its double display windows can be seen. This store had at one time been occupied by Wo On and Company, import and export merchants. (See page 106.)

By the 1890s, wooden-framed structures reminiscent of the displaced and decrepit Five Points neighborhood were being seen less and less. Not only were they more susceptible to fire, but they were also less durable than the brick tenements that were rapidly replacing them. In this image just beyond the Chinese Tuxedo Restaurant, a few wooden structures can still be seen.

This image is of Doyers Street from Pell Street. A large public bulletin board can be seen on a wall across the street. Many papers, all of which were in Chinese, were posted there daily. These included all kinds of announcements as well as advertisements. Quite frequently, large groups of people could be found here standing and reading. An awning was there to keep the readers dry on rainy days.

In this later view, a cigar shop can now be seen operating where the bulletin board stood. It is no wonder that many early Chinese immigrants who came to New York City were sellers and makers of cigars. A few hundred of the very early Chinese settlers in New York City had resettled from Havana. Havana is the place where most of the world's finest cigars were and still are produced today.

Doyers Street is considered by many to be the most unique street in New York City. Many artists chose Doyers Street to be the subject of their artwork. This etching, distributed as a postcard, was the work of Viennese artist Leon Dolice (1892–1960). Dolice spent the last 40 years of his life recording the streets, landmarks, and people of New York City in etchings.

This real-photo postcard of Doyers Street was taken in 1910 by George D. Rapp. He took the photograph while standing on the Third Avenue El. The image best exemplifies why Doyers Street had become known as the "most crooked street in New York City." The bend in the street is so pronounced that the portion beyond the bend looks to be a street perpendicular to Doyers Street rather than part of it.

Most of these old buildings still exist today in Chinatown as they had 100 years ago. Just right of the man who is holding his hat, is one of two columns. These exact columns with embossed loops as shown still stand in the same location today. Across the street in the white building is the H. Zang Milk Depot. Notice the milk can standing next to the open cellar doors.

This early-1940s image shows the exterior of the Eurasia Restaurant located at 3 Doyers Street. This animated linen pastel-colored postcard was presented to the Eurasian Restaurant's clientele free of charge. The restaurant advertised a bar as well as Shanghai and Northern Chinese cuisine, which included Peking duck. It was an air-conditioned facility as well as the new neighbor of the Rescue Society, here named the Chinatown Cathedral.

This postcard features Wah Kee Restaurant. Wah Kee Restaurant was a very successful and long-standing tiny Chinese restaurant located at 16 Doyers Street. It catered mainly to an American clientele. It was located down a steep set of narrow stairs. The tiny dining room walls were bare, save the large clock. In some Chinese villages, the displaying of a clock was thought of as to be good for business.

WAH KEE RESTAURANT
Authentic CHINESE FOOD

記 華

16 Doyers Street New York City

(CHINATOWN)

Telephone: BE 3-8582

AIR CONDITIONED

Open Daily 12 Noon to 1:30 A.M. Saturday 12 Noon to 3 A.M.

Not responsible for lost personal articles

This was the menu for the Wah Kee Restaurant. The pastel green cover had a red-inked logo surrounded by an outline of a red dragon. It advertised an air-conditioned establishment that was "open daily from 12 Noon to 1:30 A.M." and "Saturday 12 Noon to 3 A.M." The prices inside reflect early-1960s pricing. Their specialty was "crabs with black bean sauce."

This image of the bottom of the Third Avenue El shows the mouth of Doyers Street and a view of the Bowery looking west. Doyers Street can be seen coming in on the immediate left of the image. The corner storefront of the luggage and bag store that operated under the Chinese Tuxedo Restaurant at 2 Doyers Street can also be seen.

Nine

ORIGINAL CHINESE THEATER

From the beginning when the first Chinese arrived in New York City, there had always been a need for staged entertainment as a form of relaxation and a reminder of a home far away. It took many years before New York City's Chinatown would have its own Chinese theater. In the late 1880s, a San Francisco–based Chinese theater group gave New York City's Chinese a taste of good traditional Chinese theater. They appeared for a four-year tour in a theater located on New York City's Bowery. However, after the tour had ended, the Chinatown residents were left in a worse situation than if the troop had never come to town in the first place. It was like a wetting of the appetite that only led to a greater sense of disappointment when the performers left town. A short time after the San Francisco theater troop closed their curtain, a building was put up for sale. The address was 5–7 Doyers Street, which formerly served as a Sunday school for Chinese children. It was in the basement of this building that New York Chinatown would finally have its own Chinese theater. The plays were usually selected from a choice of 550 famous plays that took place in the Yuang Dynasty 1279–1368 A.D. The theater was extremely successful. And it was not only popular with Chinese but surprisingly with western audiences as well. The proof of this lies in the fact that all successful New York City motorcar tour brochures of the day advertised tours of Chinatown featuring a trip to the Chinese Theatre in their itinerary. In fact, it was either a trip to a Chinatown Chinese restaurant followed by a visit to the Chinese Theatre, or vice versa, as there were late shows as well as late-night Chinese restaurants.

This illustration depicts male and female lead actors in costume. (Brock and Golinkin, 1929.)

This view is the outside of Chinatown's Chinese Theatre, which was located at 5–7 Doyers Street. The signs out front may have been written in English, but all the plays were Chinese themed as well as conducted in the Chinese language.

Group tours to Chinatown included a trip to the Chinese Theatre. American tourists, such as the ones pictured, dressed in their Sunday best and were excited to attend a performance. Notice the sign saying "Seats reserved for Americans."

The actress pictured is dressed with much ornamentation. Her ornaments, garb, and hairstyle reflect the dynasty she is representing as well as what type of character she is portraying.

The Chinese Theatre on Doyers Street presented a great drama in this 1903 performance of *In Darkest China*. As in most bachelor society Chinatown theaters of that time, female actresses were hard to find, so many of the female roles as in this performance were also played by males.

In this sentimental yet comedic scene, a Mandarin awards his daughter to the hero of the story, a young student beggar who he has adopted as his son. In typical Chinese theater and as represented here, normally an old lady wears a bun, an old man wears a long beard, and a young man is clean shaven.

This postcard displays the full exterior of the old Chinese Theatre. It was distributed by the Rescue Society after the theater had already been closed. Notice the striking painted murals that adorned the theater's facade. Most of these paintings depicted Yuang Dynasty period actors. The windows contained artwork as well.

The Chinese Theatre building was sold in August 1910 to the Rescue Society, which was also known as the Chinatown Midnight Mission. This image displays the way the building looked after it was converted to a mission. The mission aided the homeless and the Bowery's large population of alcoholics.

Ten

Mulberry Bend Park

Mulberry Bend Park is a large public park located in Chinatown. It is one of New York City's first major urban parks. It is bounded to the north by Bayard Street, to the south by Worth Street, to the east by Mulberry Street, and to the west by Baxter Street. Through the years, it has been called a series of different names, which included Mulberry Bend Park, Five Points Park, Paradise Park, and most recently, Columbus Park. The park was conceived in the 1880s by London-born architect Calvert Vaux, who was famous for having codesigned New York City's Prospect Park, Morningside Park, and Central Park. Vaux saw the park as an opportunity to bring new life and order into a depressed and ravaged neighborhood. Solely responsible for the initiation of the transformation was the unrelenting pressure from the Danish-born journalist and social reformer Jacob Riis. His book, *How the Other Half Lives*, photographed the horridly unsanitary conditions that residents of the former Mulberry Bend, Five Points neighborhood lived in. There the death rate of children under five years of age was an appalling one out of seven. Upon completion of the park, Riis remarked that it was little less than revolutionary to see the atrocious slum housing, which included murderous alleyways with names like Bandit's Roost and Bottle Alley, be replaced by plants, trees, and fresh flowers. The park, with park bench–lined curvy walkways and wide opened grassy fields, was officially opened to the public on June 15, 1897.

This is a panoramic image of the Mulberry Bend Park. It was taken shortly after the park opened in June 1897. In this southwestern view, one sees a clear view of the structures on Baxter Street, which bordered the park to the west. Before the destruction of the former Five Points

In this view of the Mulberry Bend Park, most prominent is the group of buildings immediately to the left of the image's right border. The structures were located on Mulberry Street. These over 150-year-old tenements are still standing today and currently house most of Chinatown's funeral homes.

neighborhood, Baxter Street was Orange Street, Worth Street was Anthony Street, and Mosco Street was Cross Street.

This early-1900s image shows a great many parkgoers hanging around and relaxing in Mulberry Bend Park. Certainly a percentage of the park patrons seen here had been former residents of the recently displaced old Mulberry Bend neighborhood that became the park. Also seen is an advertising sign for India Wharf Lager Beer, as well as a large building that was in the vicinity of the park.

In this image of the Mulberry Bend Park, most prominent is the large park pavilion building, which sits at the parks northern border. This large archlike enclosed pavilion was constructed in 1897 during the park's first year of operation. Through the years, it has served as an enclosed picnic area, as well as a cool, shady place to sit and enjoy the park's atmosphere.

Almost the entire park, as well as its borders, can be seen. Noticeably in all these images of the park, virtually no people are ever seen within the boundaries of the park's many grass fields. On the park's opening day, Jacob Riis, the social reformer most responsible for the transformation, refused to attend the opening ceremonies as children were not to be allowed to play in the grass fields.

This image displays the 1950s Ethel Hing Gift Shop. It was located at 103 Park Street, just up the hill, east of Mulberry Bend Park. In this street view displaying the front of the store, an unusual pagoda-styled awning constructed of bamboo is seen. A large set of Chinese door chimes are hanging from the front door. Chinese door chimes sounded interesting, but their real purpose was to announce visitors.

This image is of the interior of the Ethel Hing Gift Shop. Ethel Hing's shop carried many different products. Seen here, her store cupboards contained chinaware, curios, lamps, back scratchers, banners, miniature parasols, fans, wall hangings, tea, and jewelry. Anyone buying an Ethel Hing item would never forget where they bought it, as her stamp and Chinese chop was printed on all the items she sold, including these Ethel Hing postcards.

ACROSS AMERICA, PEOPLE ARE DISCOVERING
SOMETHING WONDERFUL. *THEIR HERITAGE.*

Arcadia Publishing is the leading local history publisher in the United States. With more than 3,000 titles in print and hundreds of new titles released every year, Arcadia has extensive specialized experience chronicling the history of communities and celebrating America's hidden stories, bringing to life the people, places, and events from the past. To discover the history of other communities across the nation, please visit:

www.arcadiapublishing.com

Customized search tools allow you to find regional history books about the town where you grew up, the cities where your friends and family live, the town where your parents met, or even that retirement spot you've been dreaming about.